COLOR · IN · REVERSE

Watercolor Florals

Let your creativity and pen flow
over delightful watercolor designs

HEINKE NIED

Quarto.com • WalterFoster.com

© 2023 Quarto Publishing Group USA Inc.
The original German edition was published as Das Rückwärts-Ausmalbuch.
Copyright © 2022 frechverlag GmbH, Stuttgart, Germany (www.topp-kreativ.de)
This edition is published by arrangement with Anja Endemann, ae Rights Agency, Berlin, Germany.

Published in 2023 by Walter Foster Publishing, an imprint of The Quarto Group.
100 Cummings Center, Suite 265D, Beverly, MA 01915, USA.
T (978) 282-9590 **F** (978) 283-2742

Walter Foster Publishing titles are also available at discount for retail, wholesale, promotional, and bulk purchase. For details, contact the Special Sales Manager by email at specialsales@quarto.com or by mail at The Quarto Group, Attn: Special Sales Manager, 100 Cummings Center, Suite 265D, Beverly, MA 01915, USA.

ISBN: 978-0-7603-8327-8

Artwork and drawings by Heinke Nied
Translation by Hazel Blumberg-McKee

Printed in the United States
10 9 8 7 6 5 4 3 2

Foreword

Hello!

I'm so pleased that you're here and that you've decided to give creative relaxation a try. This book will take you on a meditative yet inspiring journey full of color, design, and patterns. With this book, I seek to help you relax and enjoy the calming flow of drawing. Let it serve as your meditation practice in your daily life—your island of calm, helping you refuel or discover your creative energy.

In this book, you'll find dozens of lightly painted watercolors that you can re-interpret with your own simple lines. Draw and doodle right on top of the watercolor pieces using lines, shapes, and anything that occurs to you. Everything is allowed; everything is possible. You need only a black pen for your creativity to begin.

Let yourself be inspired by the various forms and colors on the pages. Immerse yourself in the world of color, drawing your designs and patterns as you wish. There are no expectations for what the art you create should look like, and no judgment. This book is your place to relax. The result isn't important here. Discover how to draw new patterns and forms on top of the watercolors, and let yourself be surprised by your own creativity. You'll see that drawing and doodling will become easier over time.

The opening pages of the book include information, drawing guidelines, inspiration, and tips that will help you draw pictures inside the book. Then dive into the watercolor pages and let yourself draw intuitively, mindfully, and effectively.

I wish you much joy. Live creatively!

Best,

Heinke

Finding Calm & Relaxation

Drawing on the pages within this book will help make you feel more relaxed and observant. Meditative drawing allows you to calm yourself and will have a positive effect on your overall health. The most important thing is that you let yourself experience meditative drawing.

TIP

Create a relaxed atmosphere in a specific place—your island of calm—where no one disturbs you so that you can become totally engaged in drawing. The best part is that you don't have to think about which colors to use because they are already right here on the page. You also don't have to give a lot of thought to what you want to draw. Orient yourself to the forms of the watercolors. Look carefully at the individual little spots on different-colored backgrounds, and you will see that you recognize different forms and patterns in them. You might see flowers, leaves, trees, animals, faces, birds—or something else entirely.

My Island of Calm

Here are some tips that I hope will help you relax before you begin drawing.

1. Sit down in a comfortable, pleasant spot of your choice.
2. Put your feet down firmly to ground yourself.
3. Close your eyes.
4. Breathe deeply in and out a few times, concentrating completely on your breathing.
5. Warm your hands by opening and closing them several times, and then stretch your fingers gently.
6. Select your first watercolor to draw on, looking first at the colors and forms that you see.
7. Start drawing with a marker or a pen. It doesn't matter where on the picture you choose to begin.
8. Enjoy yourself—and your finished artwork.

How I Begin

Are you unsure where or how to begin? Over the following pages, I've shared with you some ideas and inspirations. You can use different thicknesses of pens, as well as add color to your drawings. Follow your feelings and do what you like!

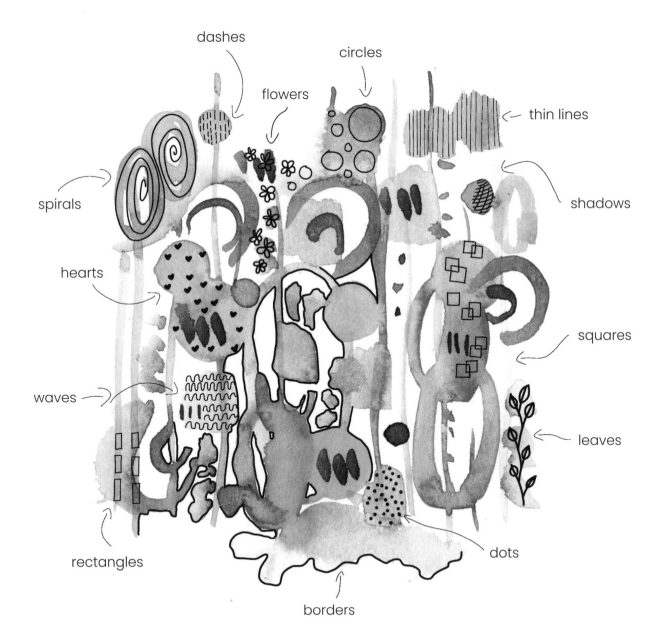

dashes

circles

flowers

thin lines

spirals

shadows

hearts

squares

waves

leaves

rectangles

dots

borders

Tools & Materials

You can use different types of pens or markers to make your lines, designs, and drawings.

BRUSH PEN

Faber-Castell® Pitt Artist Brush Pen in black. With its flexible felt-tip point, you can draw thick and thin lines depending on how much pressure you apply to the tip.

FINELINER PEN

Faber-Castell Ecco Pigment Pen in various nib thicknesses. These contain pigmented ink.

FELT-TIP MARKERS

Uni® Chalk Marker (white)

There are countless types of markers from different manufacturers, and you're free to pick any colors, brands, and types that you like. Use what makes you feel comfortable.

Edding® Permanent Marker (black)

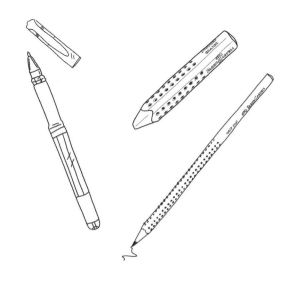

TIP

A thicker felt-tip pen allows you to make dots more easily.

Inspiration

This watercolor pattern clearly depicts an airy bouquet of flowers. Here I've shown you two options for how you could draw on top of the watercolor, and even though the technique used is the same, the results look completely different.

More Inspiration

You can use your drawings to flesh out abstract watercolor backgrounds in different ways. For example, create an abstract drawing consisting of lines and points, or draw smaller trees or butterflies.

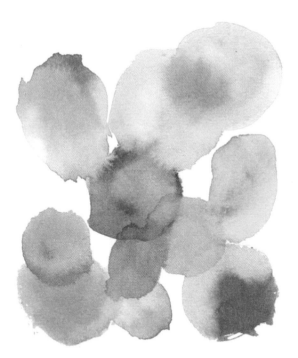

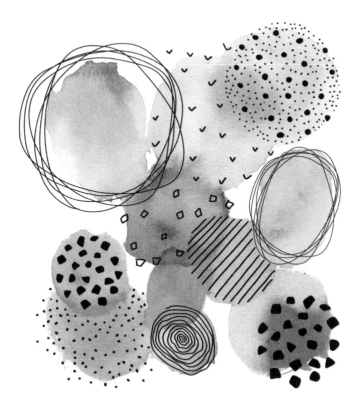

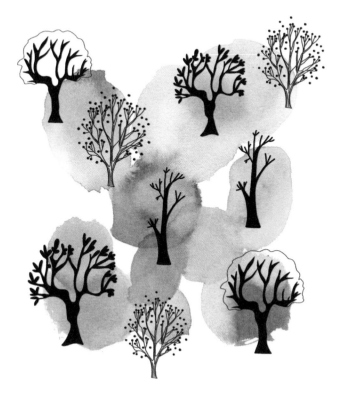

Sample Shapes

The nib size of your felt-tip pen will create different effects. Try different sizes and discover the many possibilities.

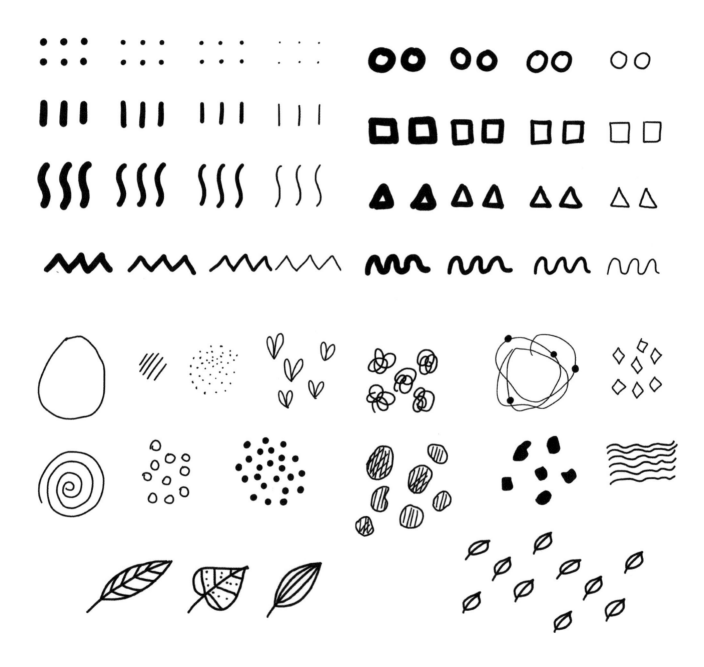

Patterns & Lines

Has it been a long time since you last drew something? Start with patterns and lines. This fun technique always produces a beautiful result.

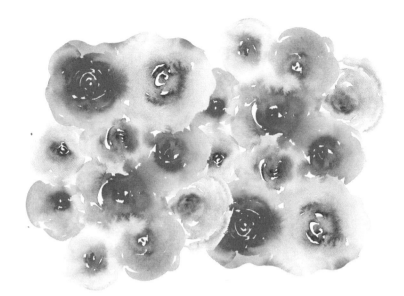

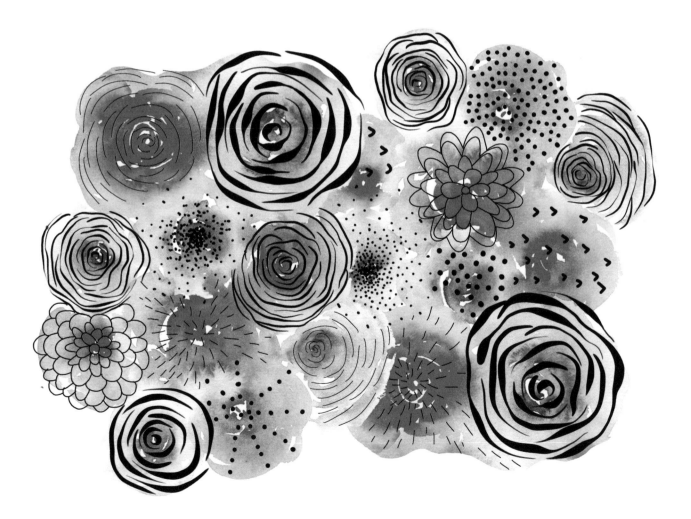

One-Line Art

One-line drawing means drawing in a single continuous line to create a piece of art. This is a great technique for relaxation. Here I've shared some of my drawings in case they inspire you.

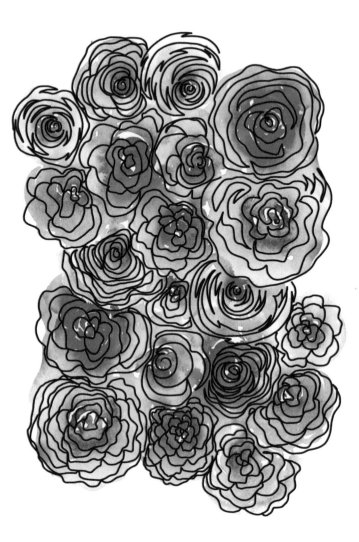

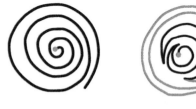

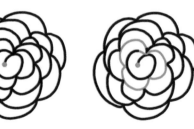

TIP

Start by warming up your wrist by drawing spirals, always changing the direction of the spiral. Once you're warmed up, draw the shape again—but make it wave-shaped. You'll see that a flower appears on its own. Repeat these steps again and again to get into a good flow as you draw. I think you'll really enjoy this technique!

One-Line Methods

See how easy it is to draw flowers and leaves with one continuous line?

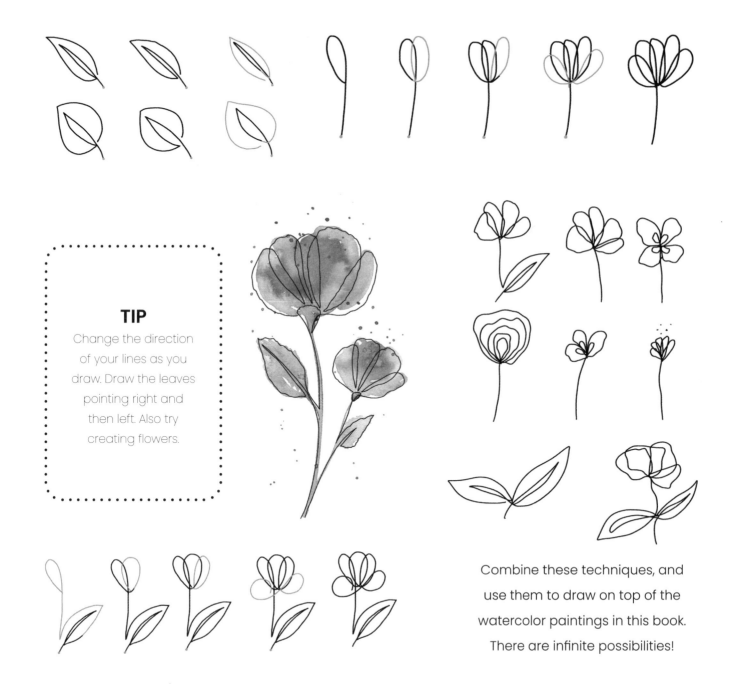

TIP

Change the direction of your lines as you draw. Draw the leaves pointing right and then left. Also try creating flowers.

Combine these techniques, and use them to draw on top of the watercolor paintings in this book. There are infinite possibilities!

Getting Started

Here I've started the drawing for you. Continue drawing after me and see what you come up with!

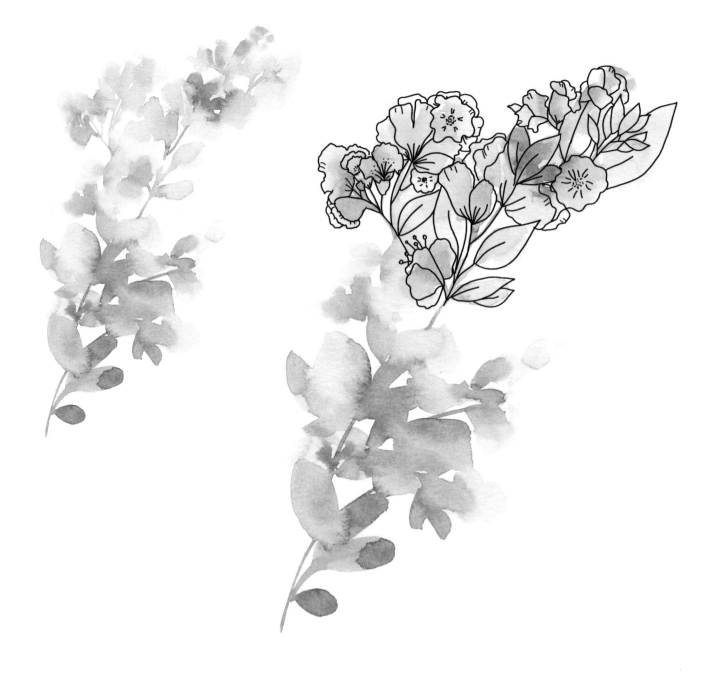

Drawing Faces

In addition to flowers, leaves, and abstract designs, it's fun to see if you can pick out faces or animals within the watercolor backgrounds. Here I've shown you a simple, step-by-step way to draw a variety of faces.

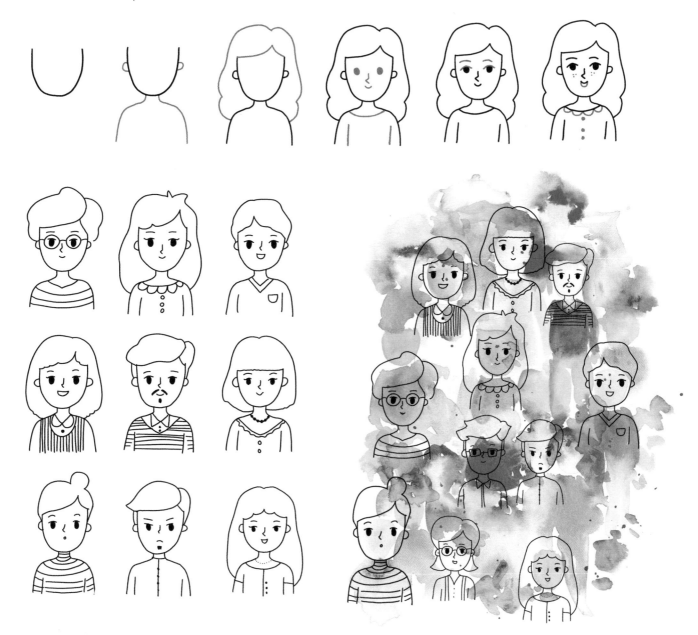

Now it's Your Turn!

Try drawing your own faces right here. Just by glancing at the watercolor background, you'll likely see some individual faces and people. Draw them in with the fineliner pen of your choice.

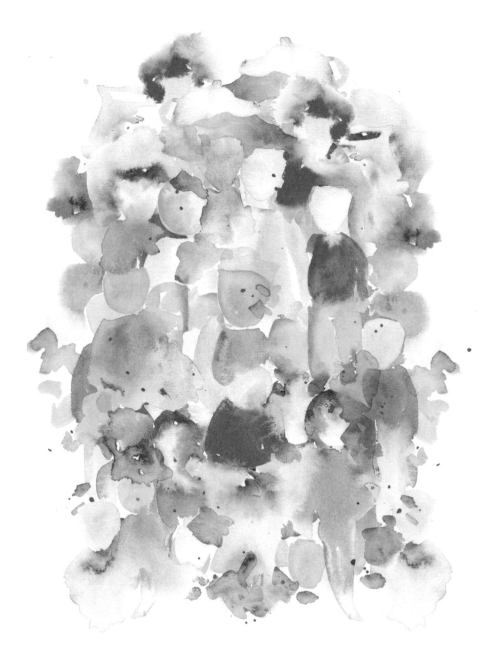

Drawing Animals

Here is an easy technique for drawing an animal. It doesn't have to be perfect. What's important are the characteristic features that make an animal recognizable. But you can also draw fantasy animals. The main thing is that it should be fun!

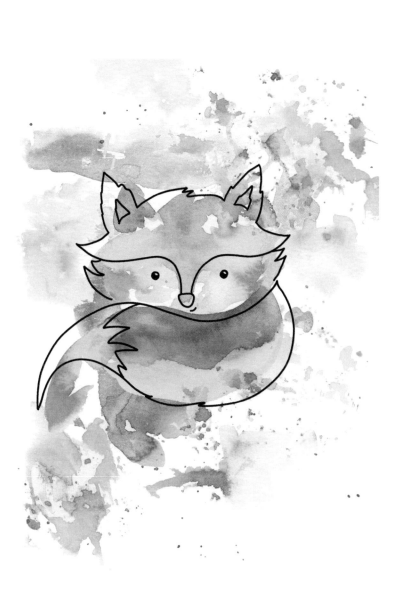

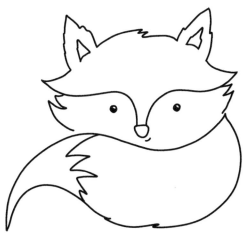

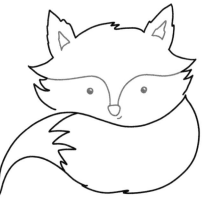

Bird

Drawing a bird can be quite simple too.
Here I show you how to do it, step by step.

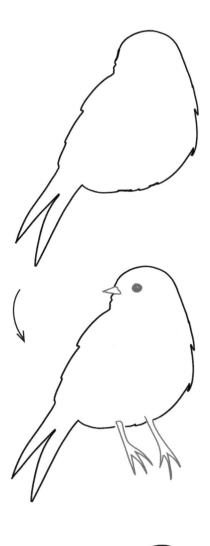

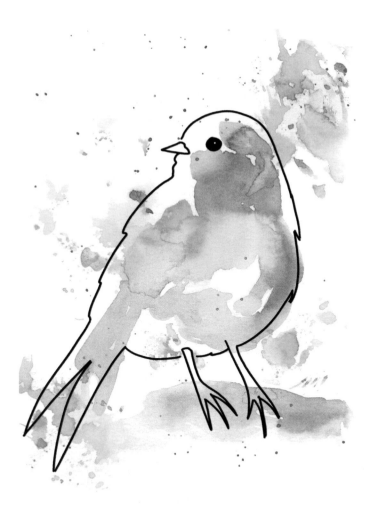

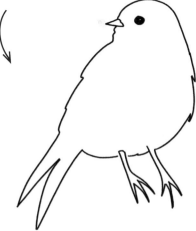

Birds & More

Use your pen to tell an entire story—for example, these little birds sitting in a tree, surrounded by foliage and individual leaves.

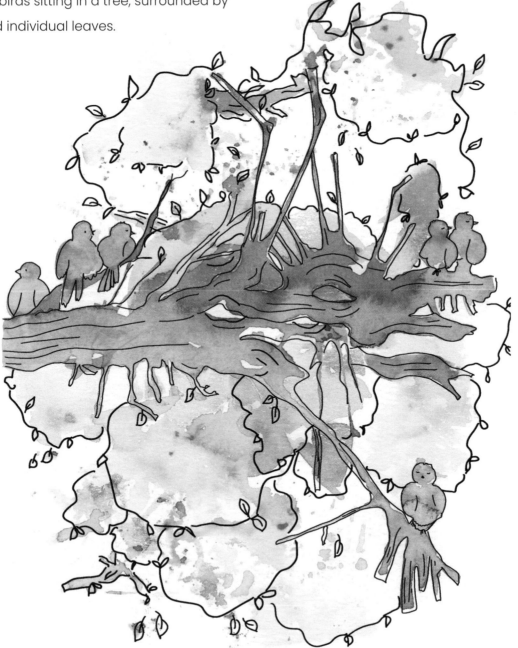

Watercolors

Maybe you want to create your own watercolor backgrounds to draw and doodle on top of. Use the items below to paint your own watercolor backgrounds.

YOU WILL NEED

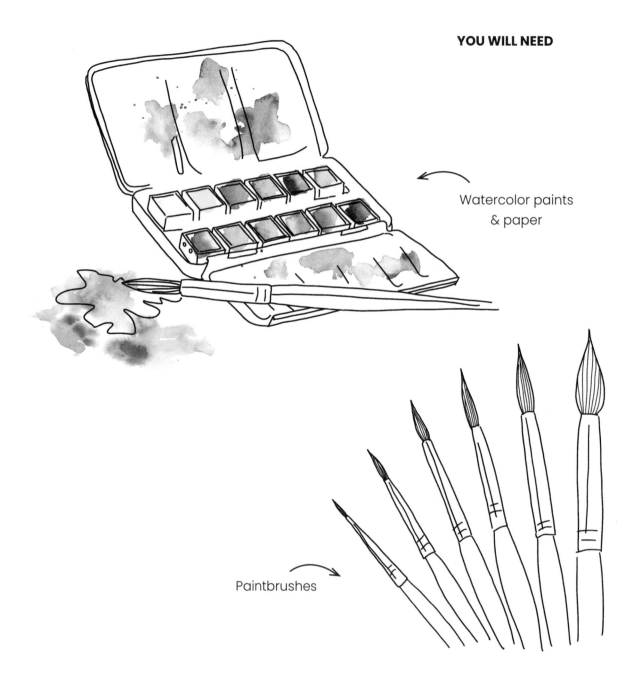

Watercolor paints
& paper

Paintbrushes

A Little Bit of Color Theory

If you would like to paint with watercolors, it will help to familiarize yourself with color theory.

PRIMARY COLORS

- Red
- Yellow
- Blue

These colors cannot be created by mixing any other colors.

SECONDARY COLORS

- Red and yellow make orange.
- Red and blue make violet.
- Blue and yellow make green.

Two primary colors are mixed to create secondary colors.

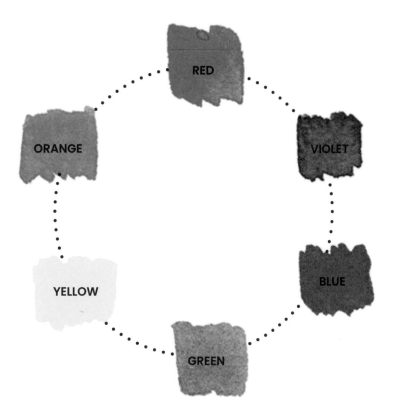

Painting Wet-on-Dry

With the wet-on-dry technique, layers of color are painted one after the other onto dry watercolor paper. Only when the first layer is completely dry is the next layer applied. If the layers are very thinned out and placed on top of each other, they will appear transparent and show through, yielding a beautiful effect.

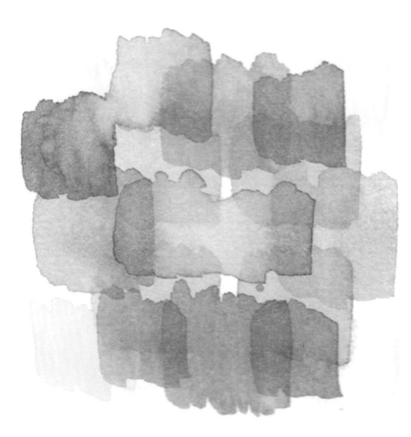

Adding a Wash of Color

Adding a wash means using the wet-into-wet technique to create a faded or washed-out look. When using the wet-into-wet technique, you paint color on top of an already-wet surface. Thus, little explosions of color are formed, and colors mix with one another.

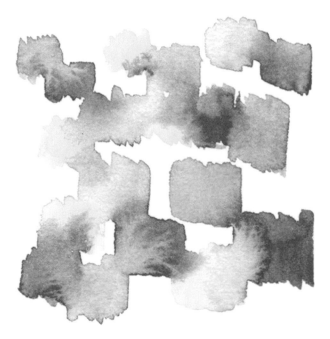

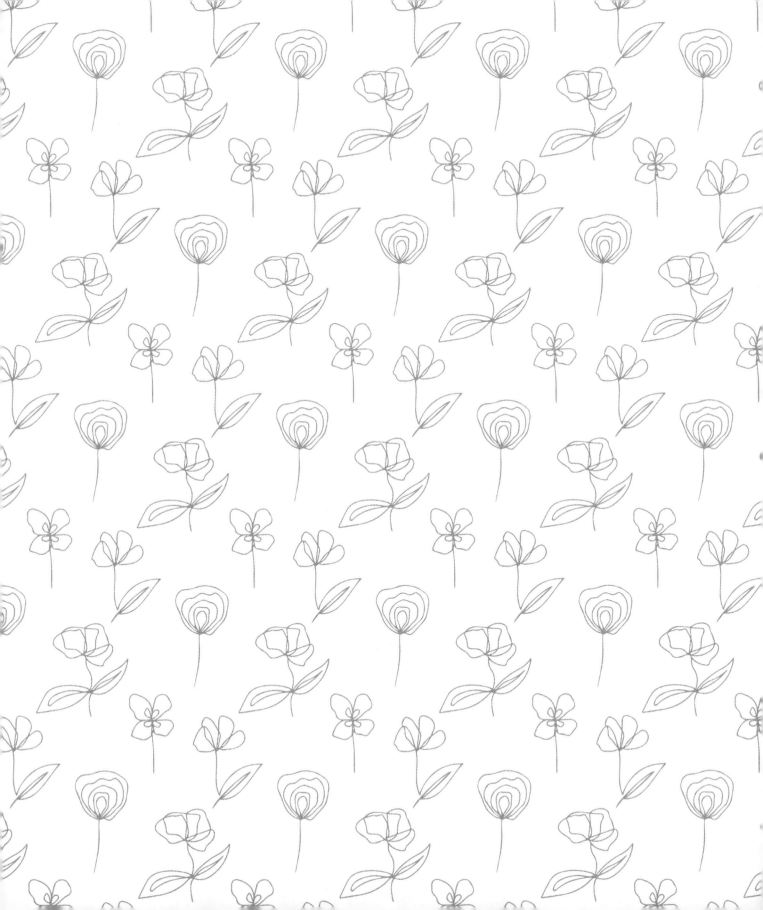

Patterns

Now, let's begin! All of the patterns in the book
can be embellished any way you like.

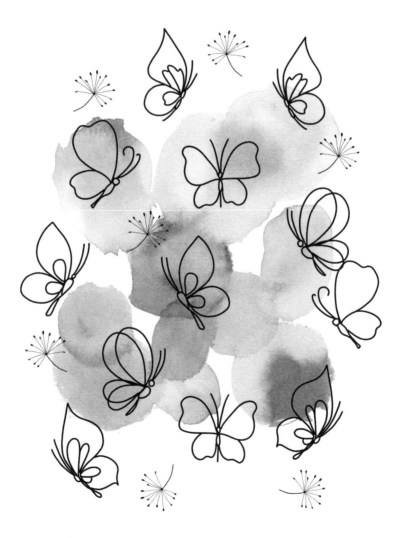

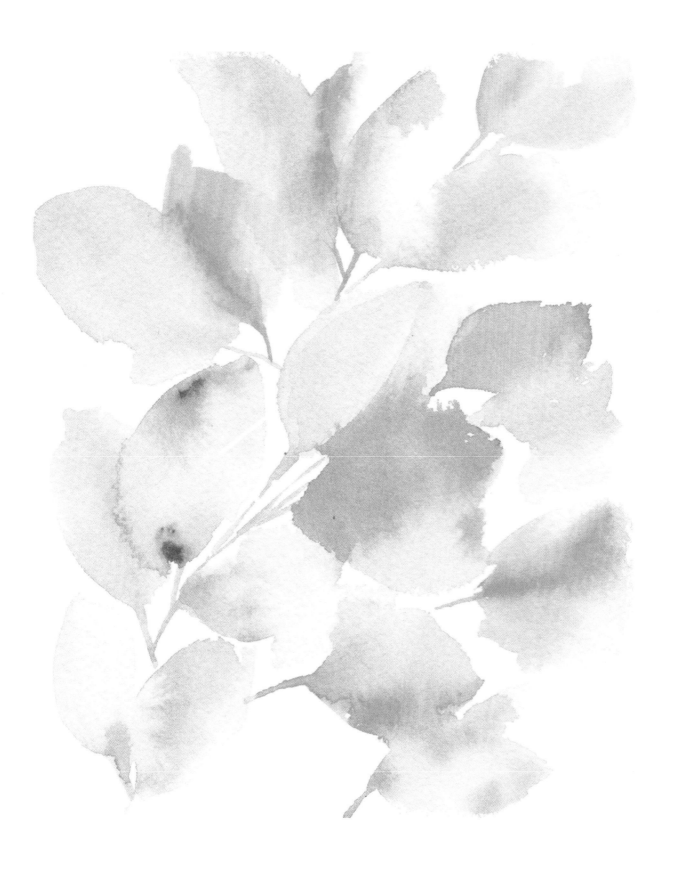

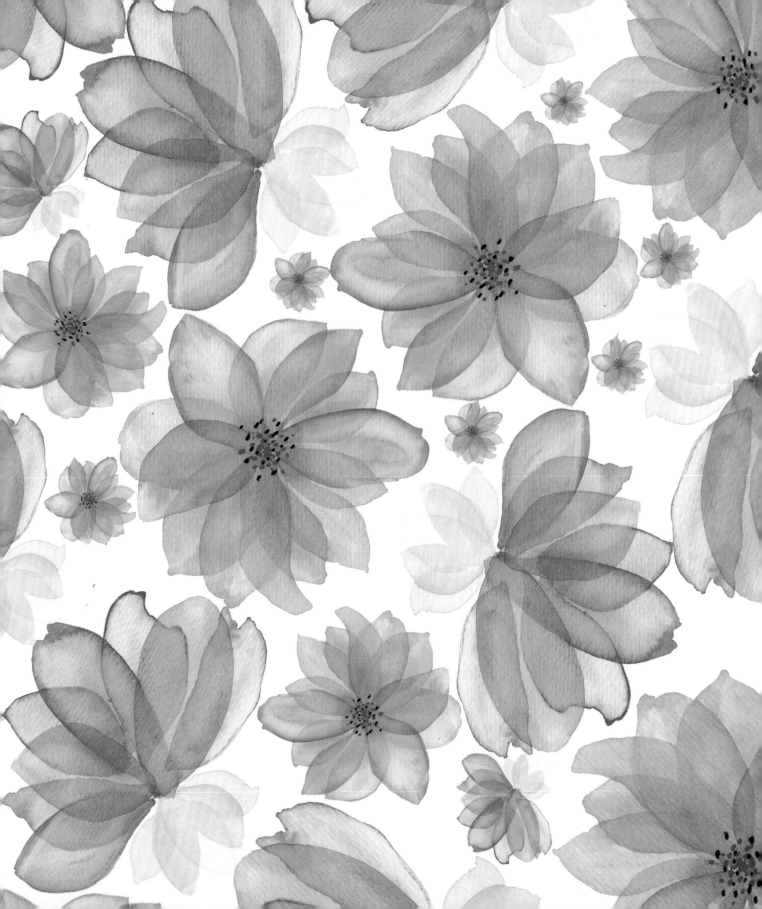

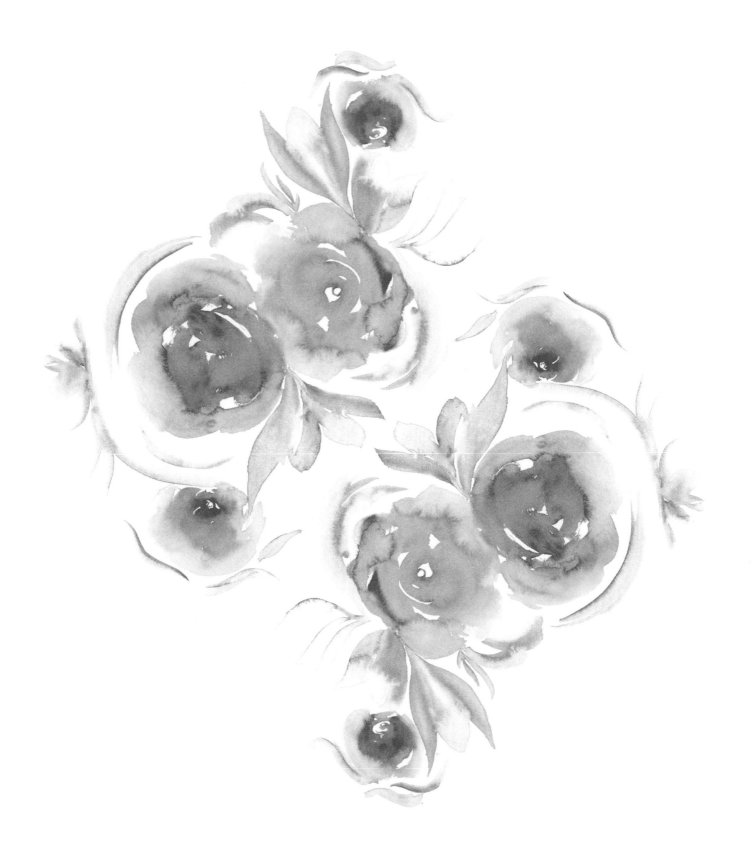

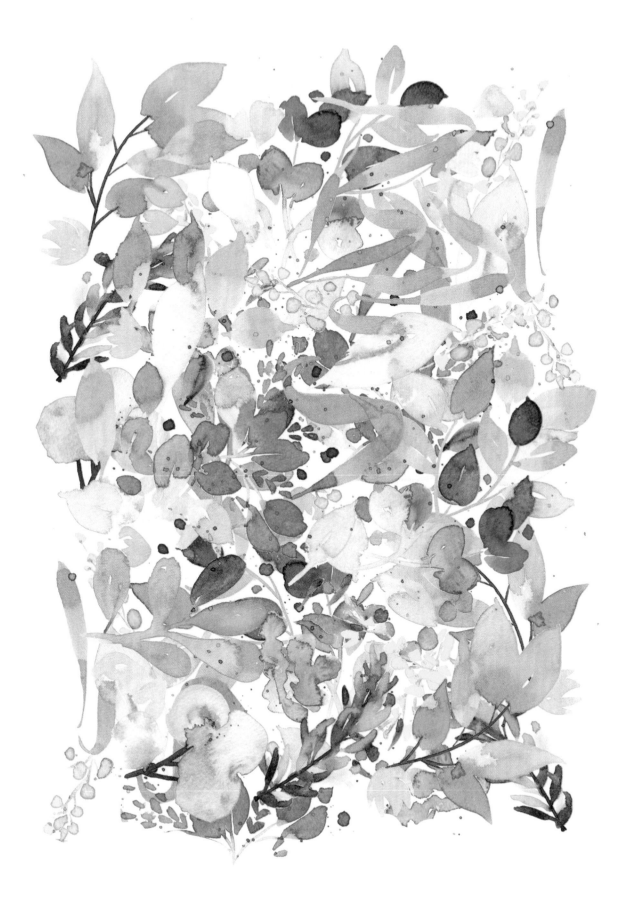

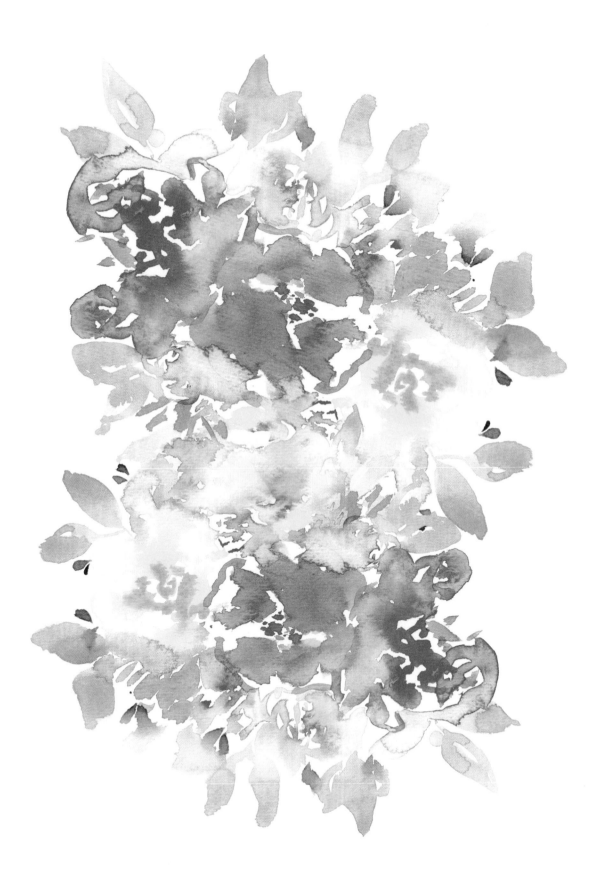

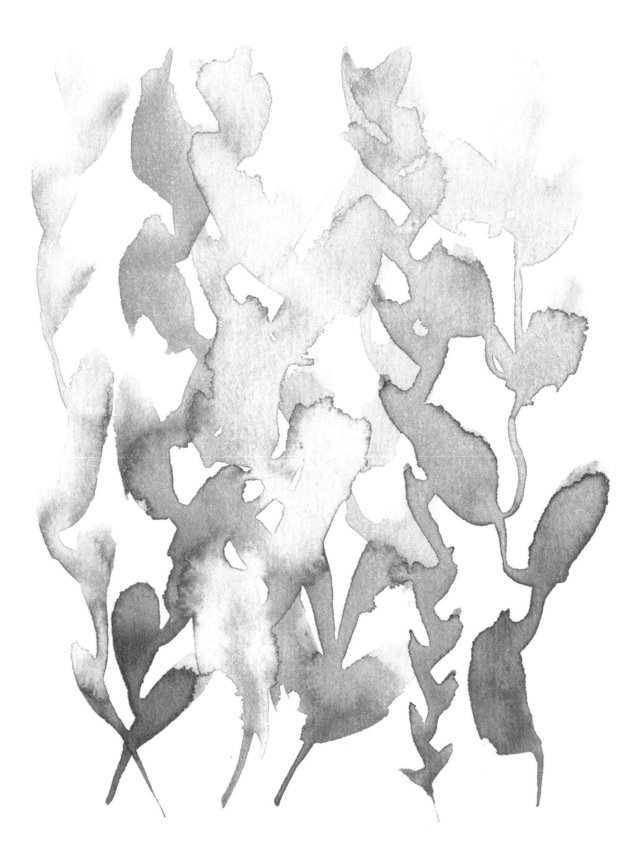

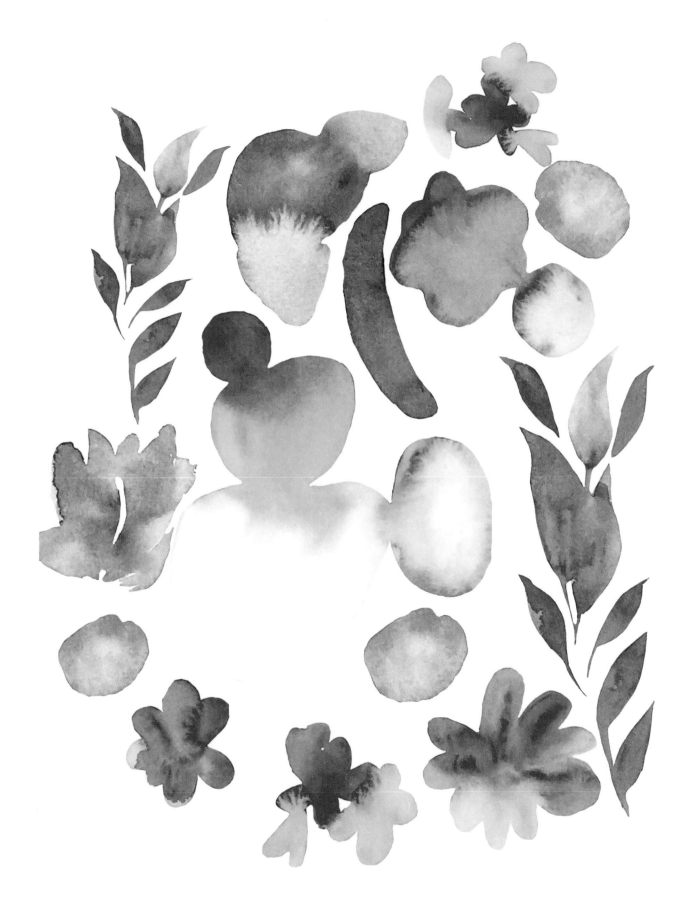

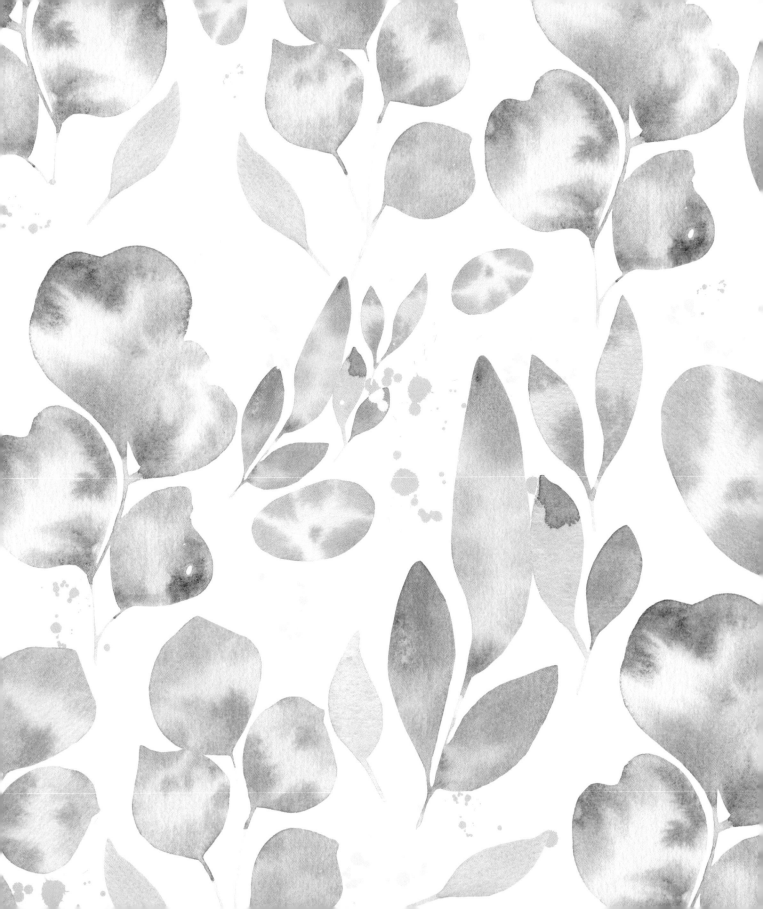

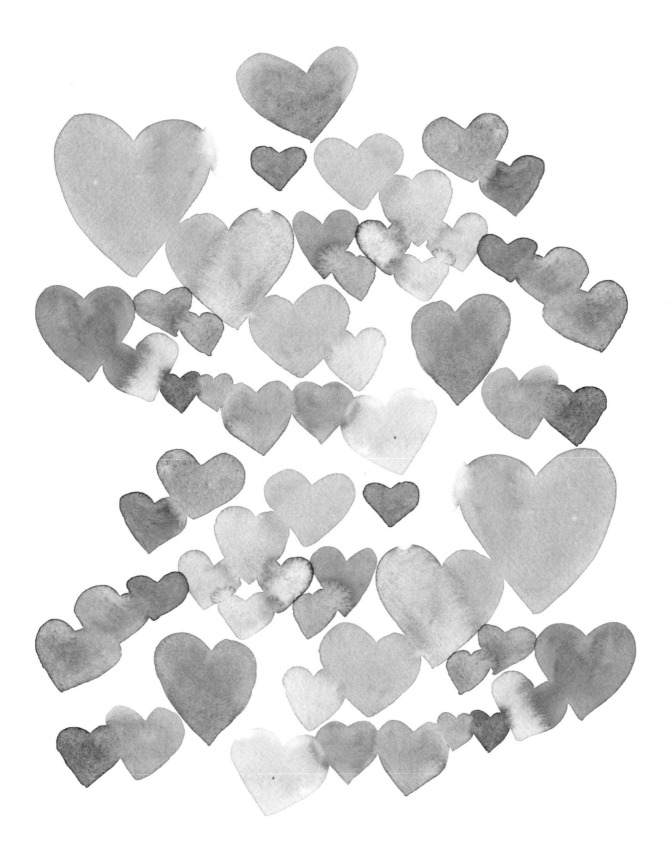

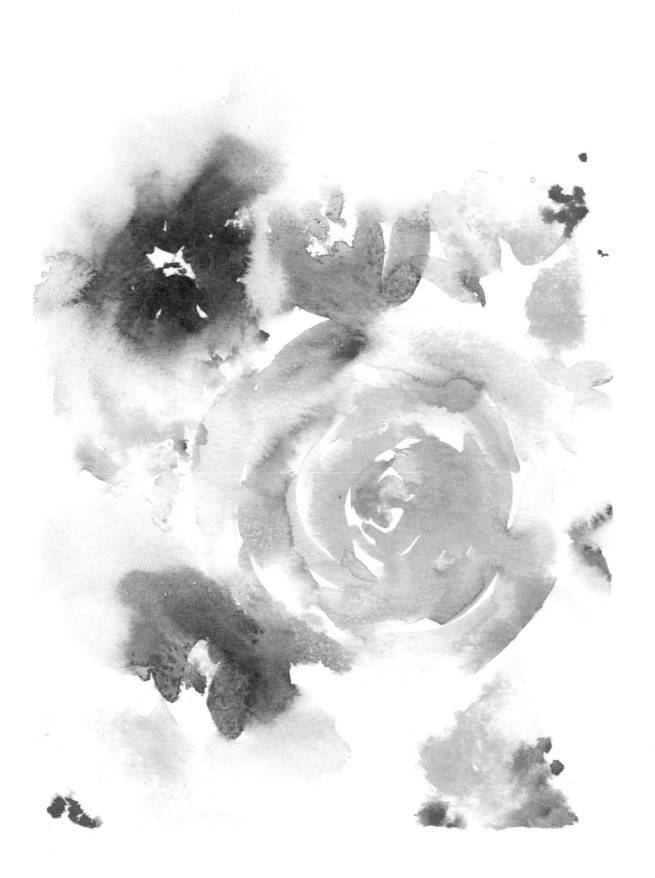

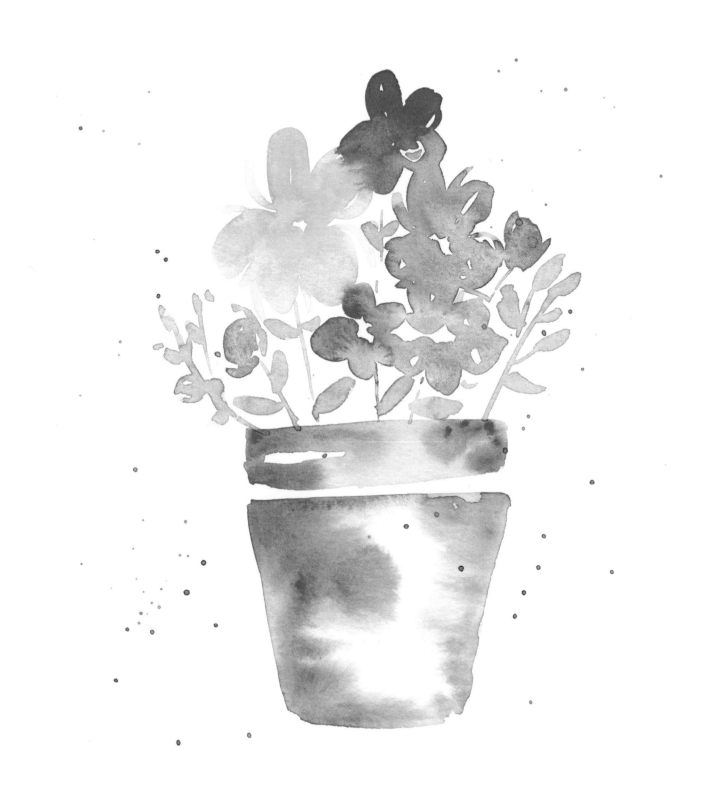

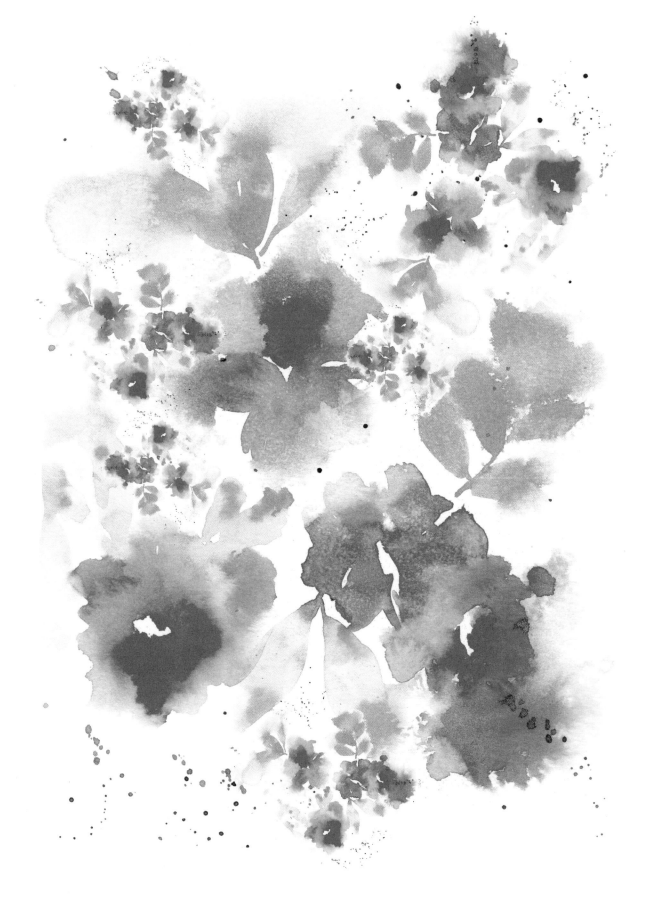

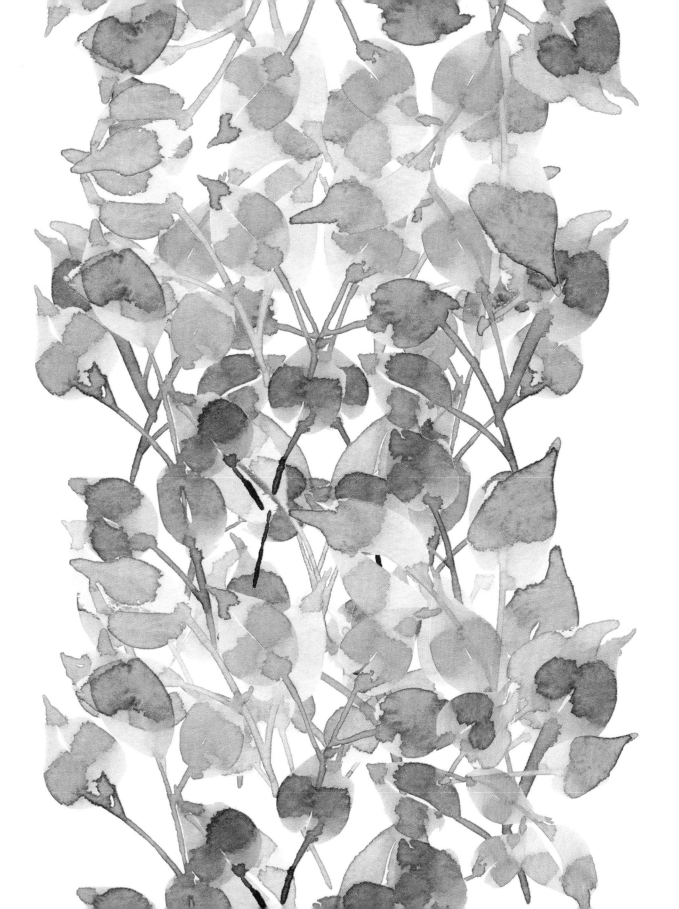

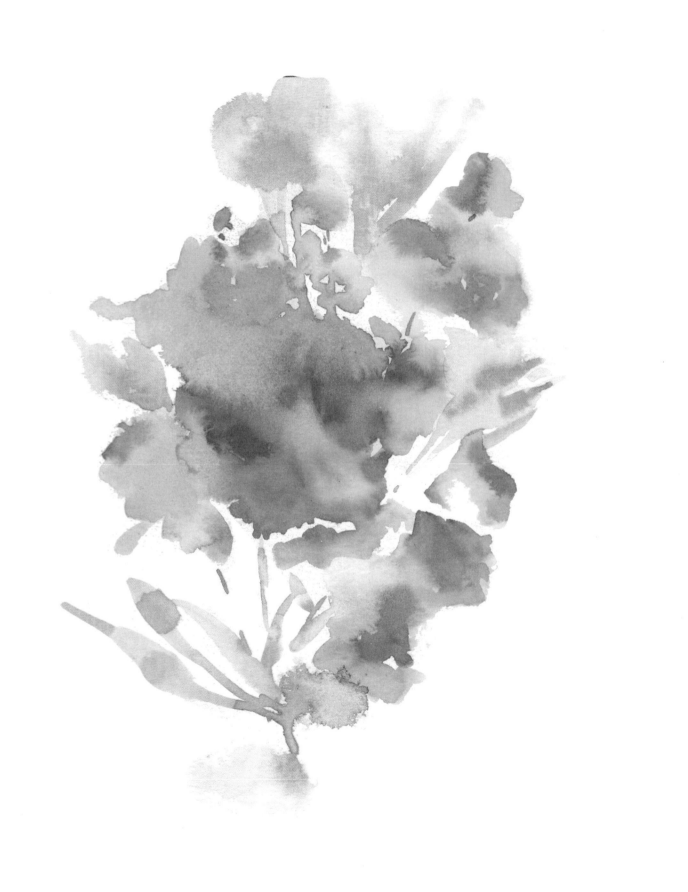

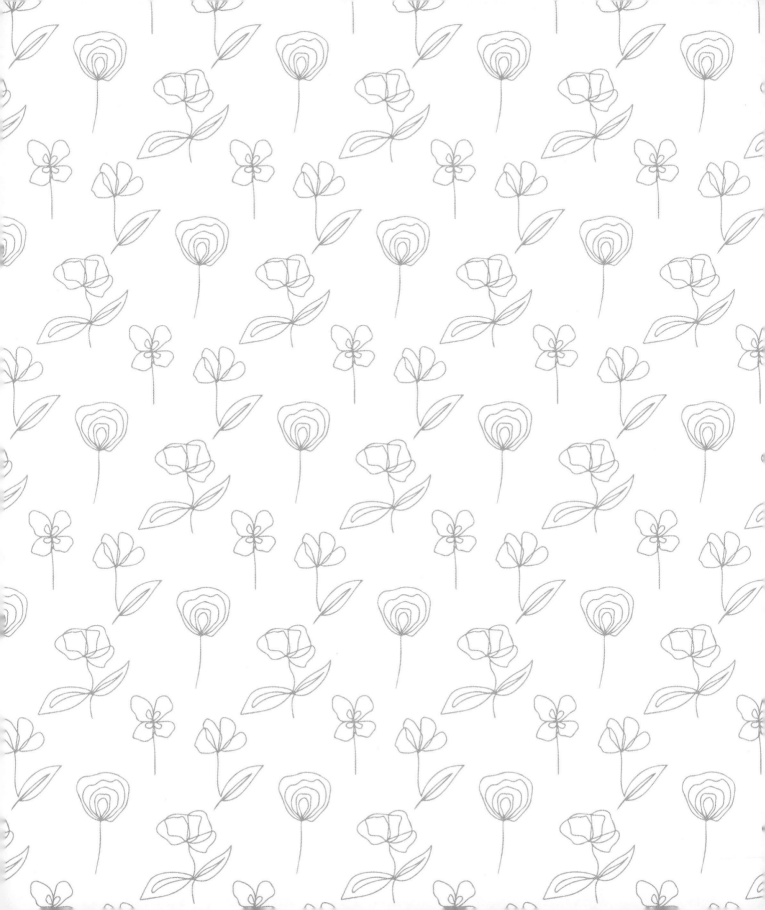

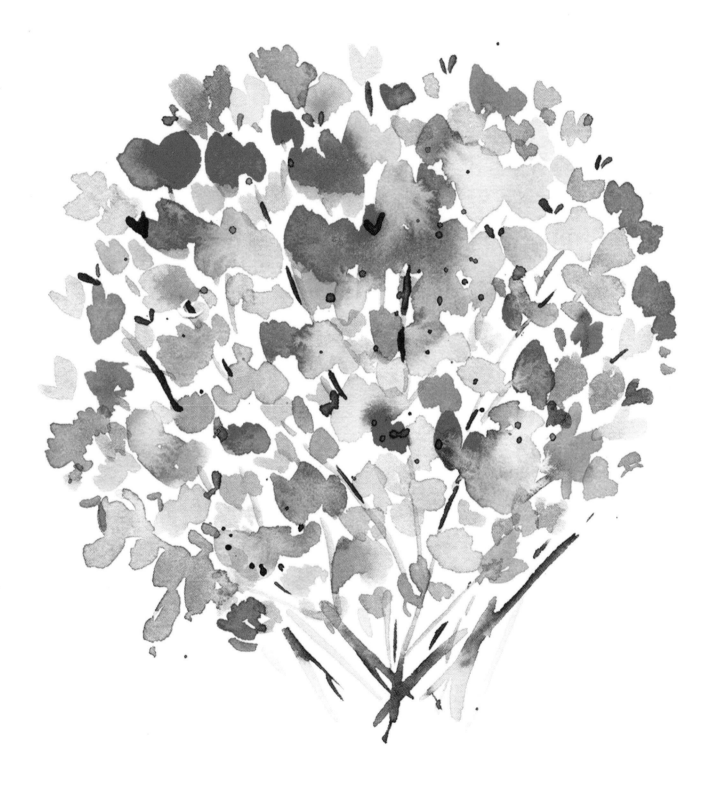

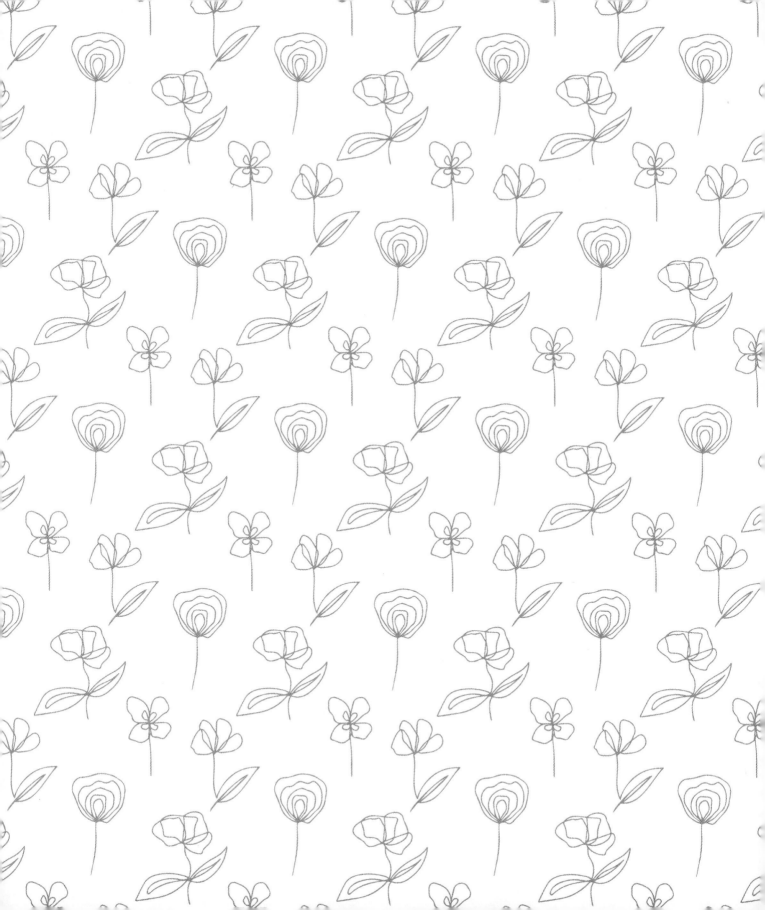

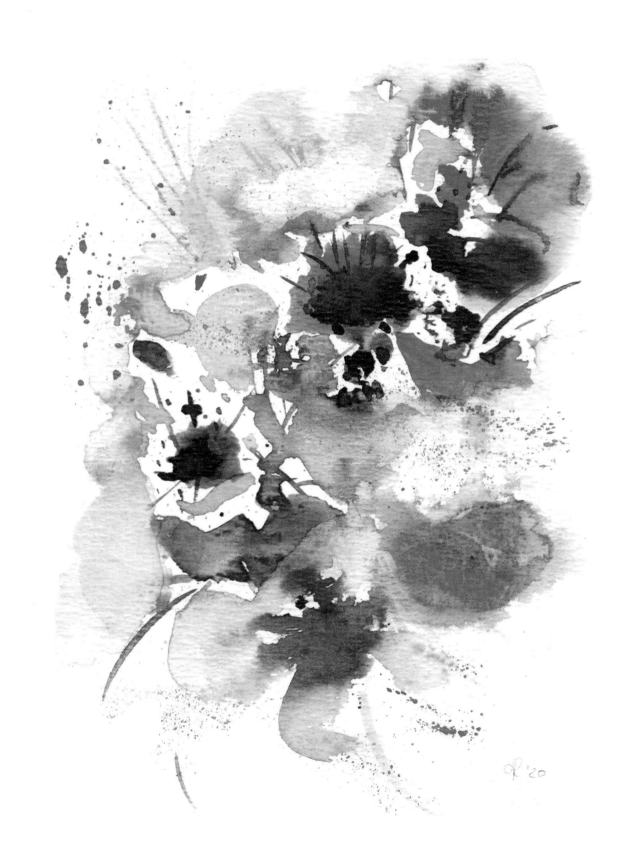

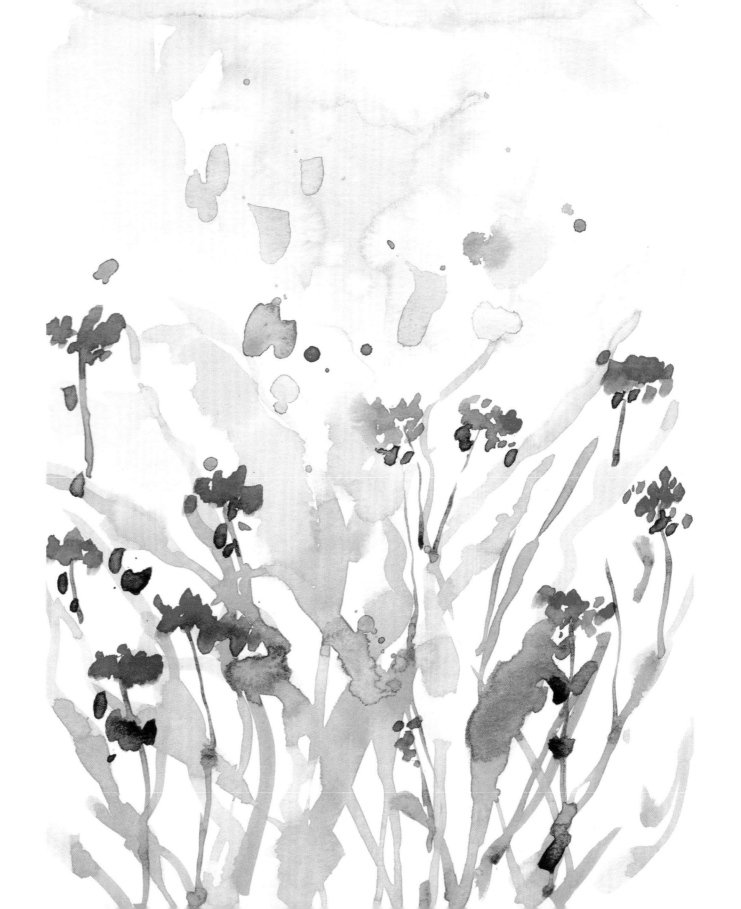

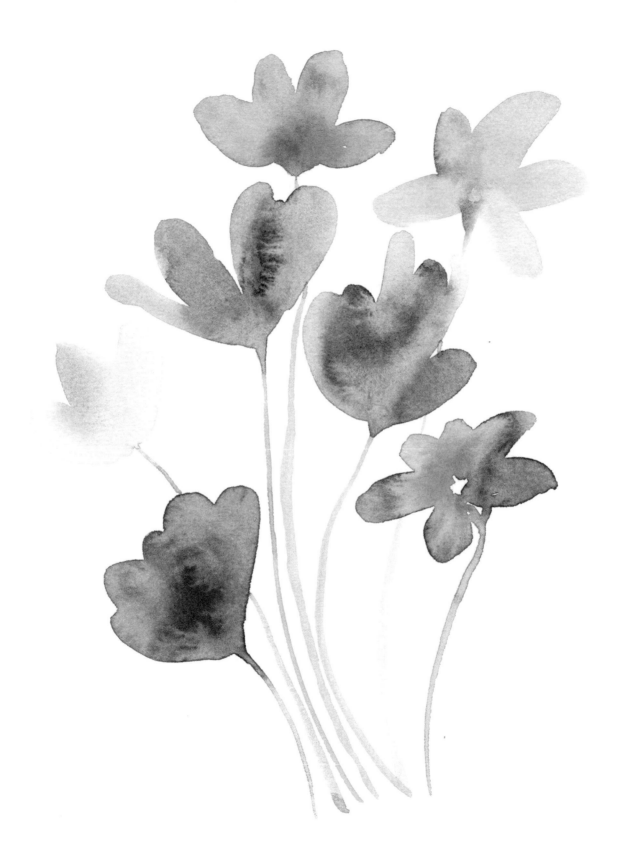

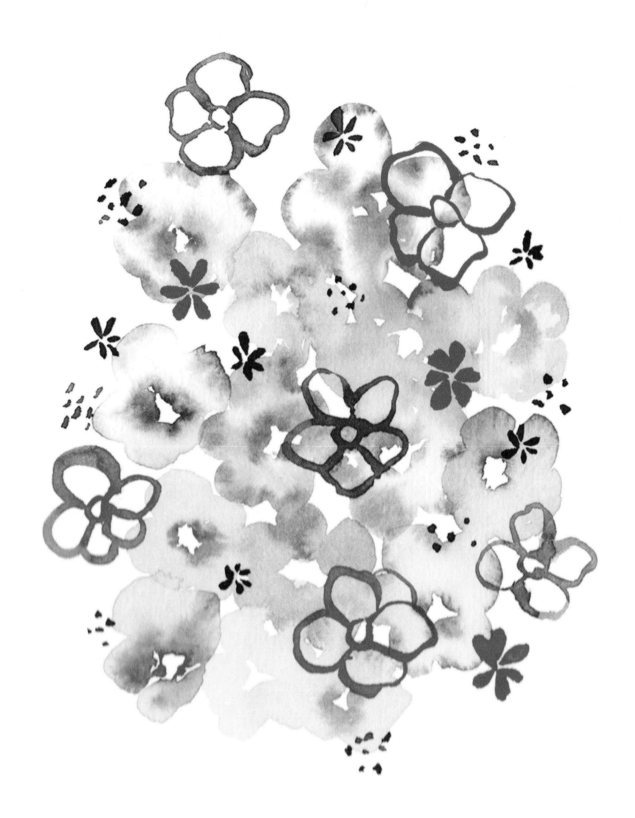

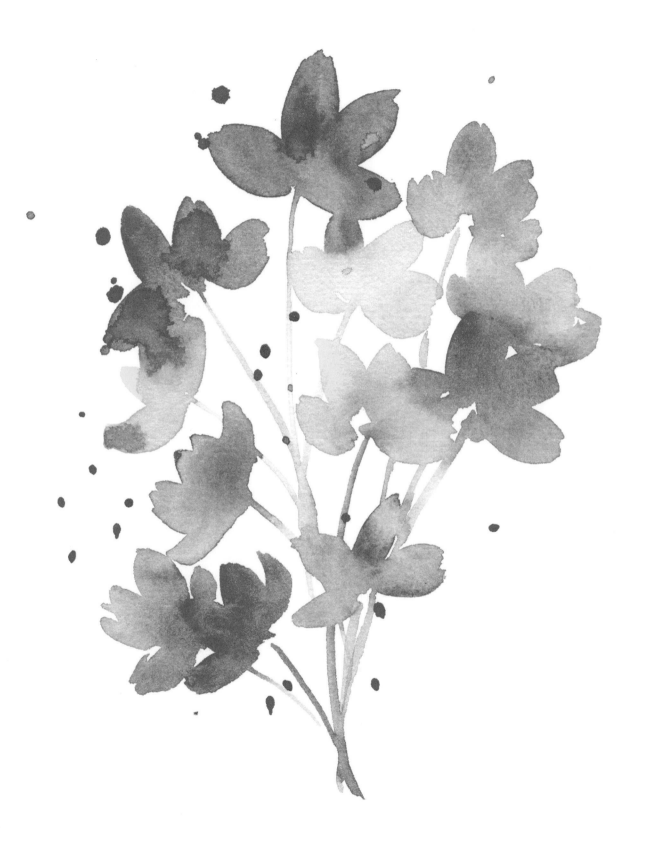

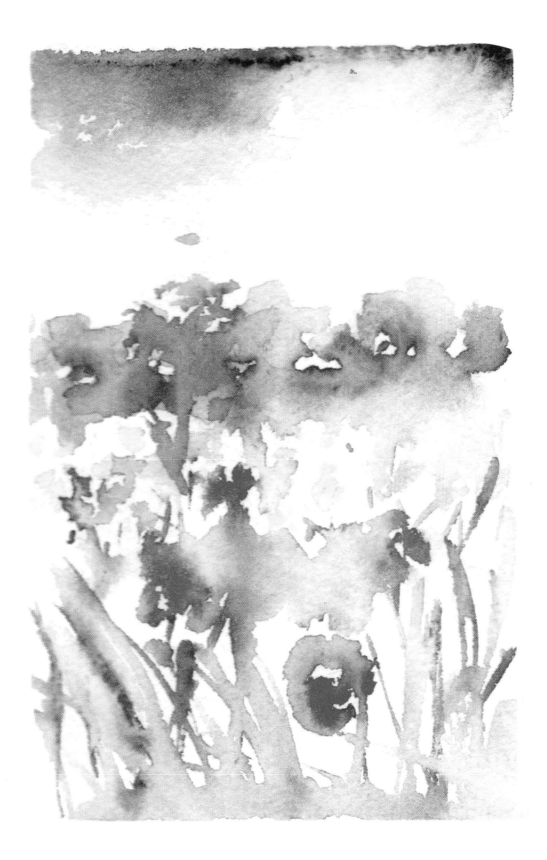

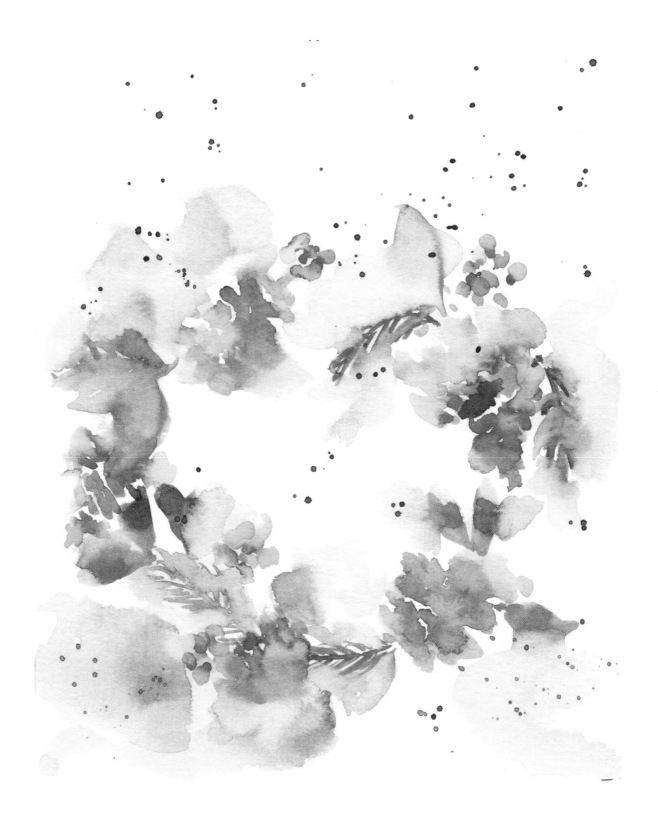

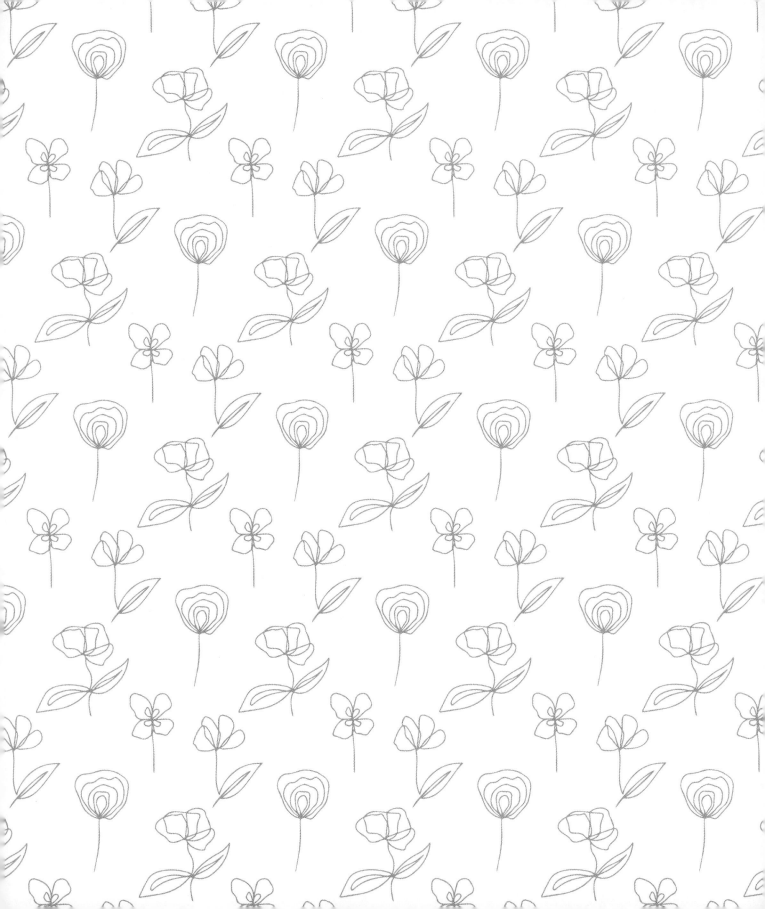

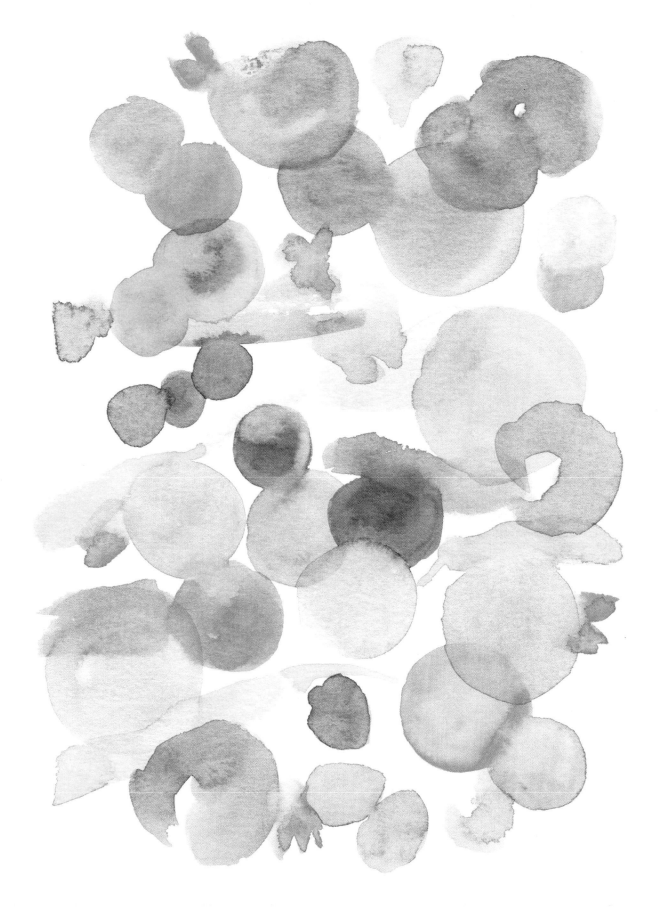

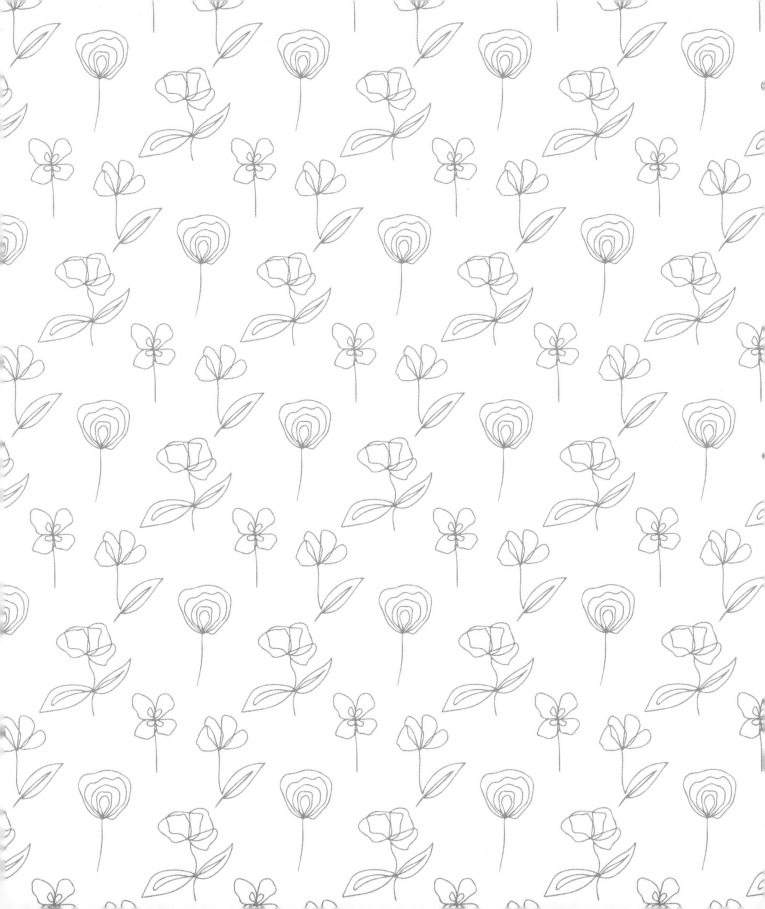

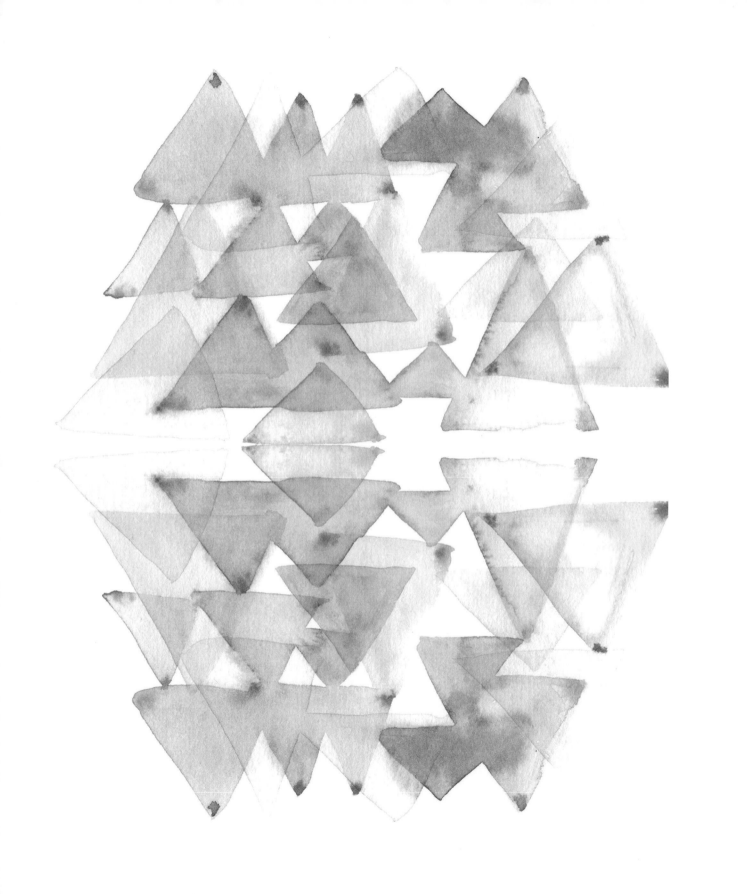

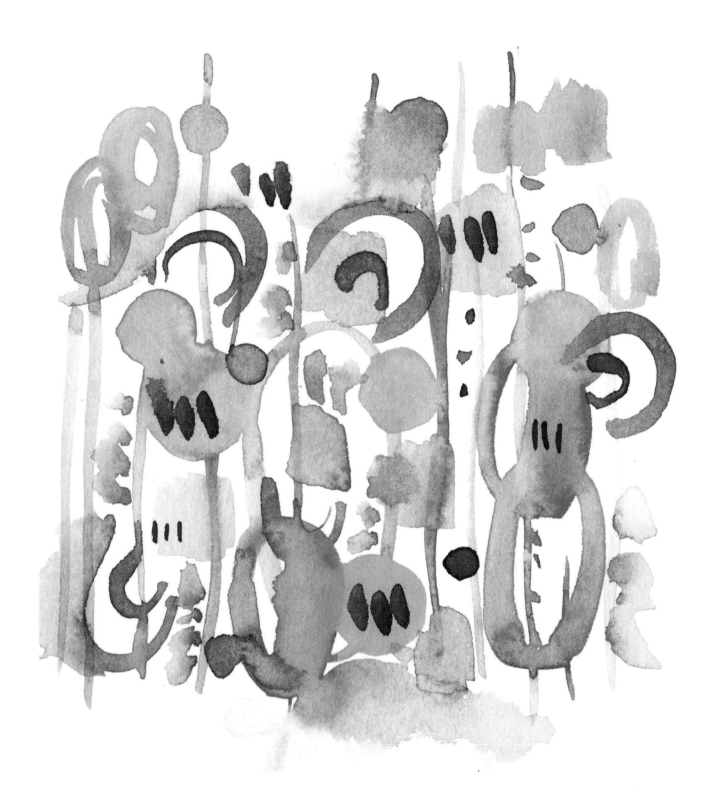

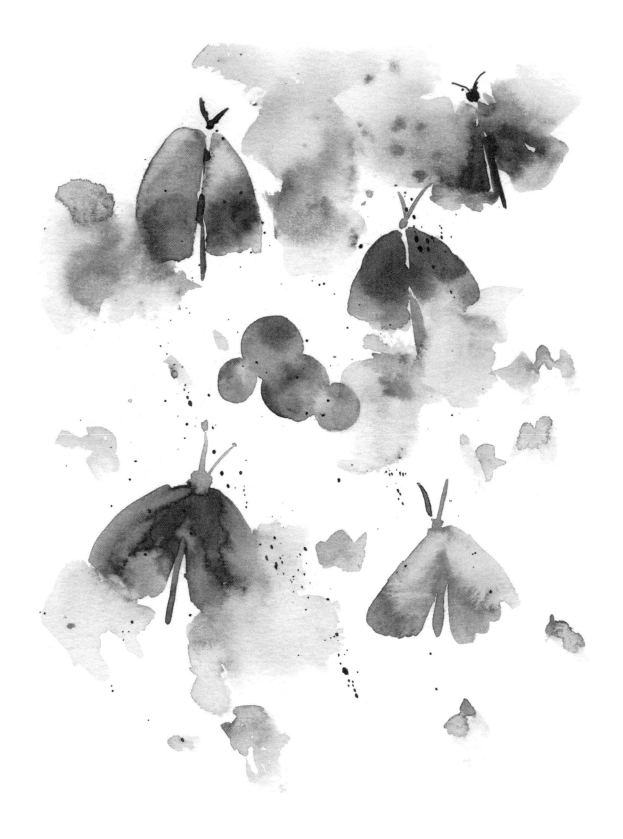

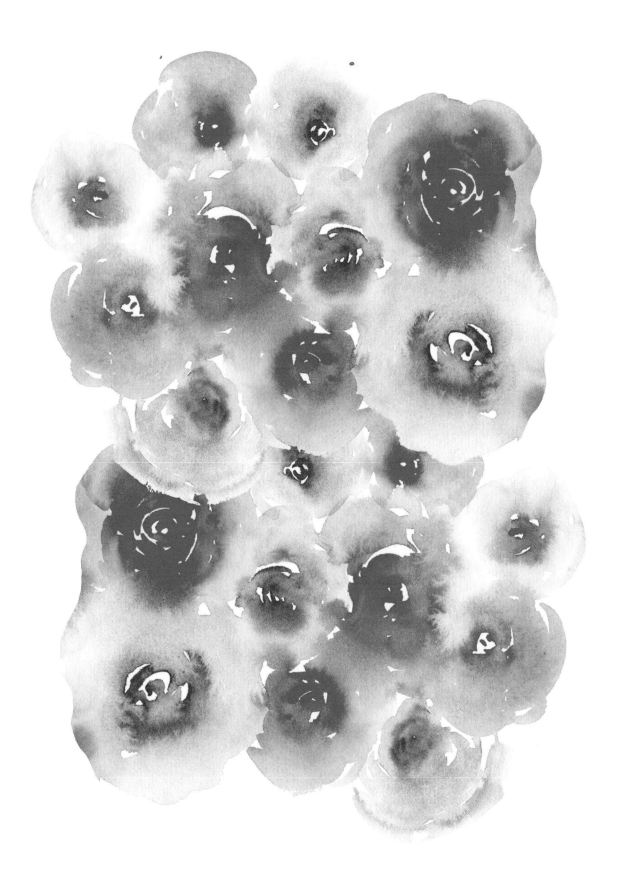

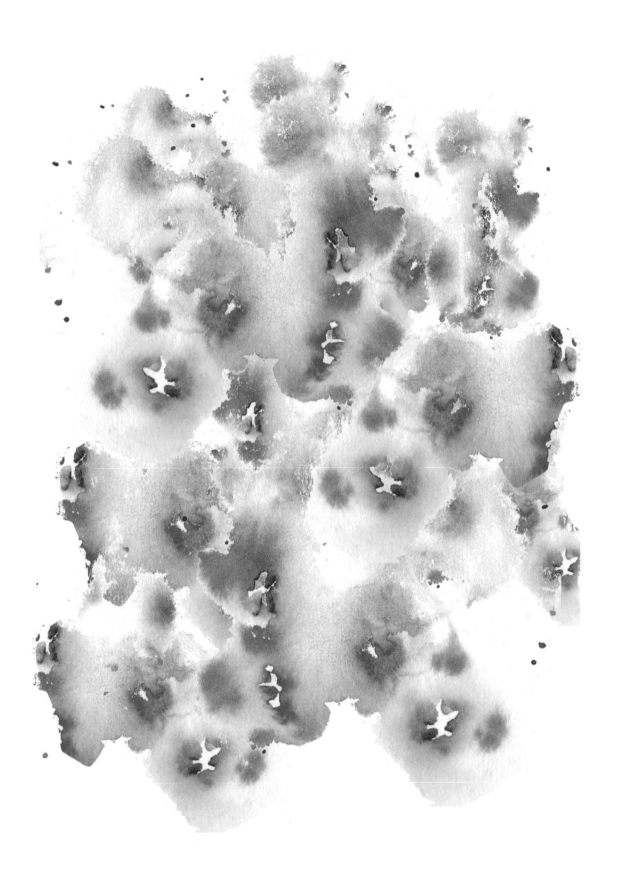

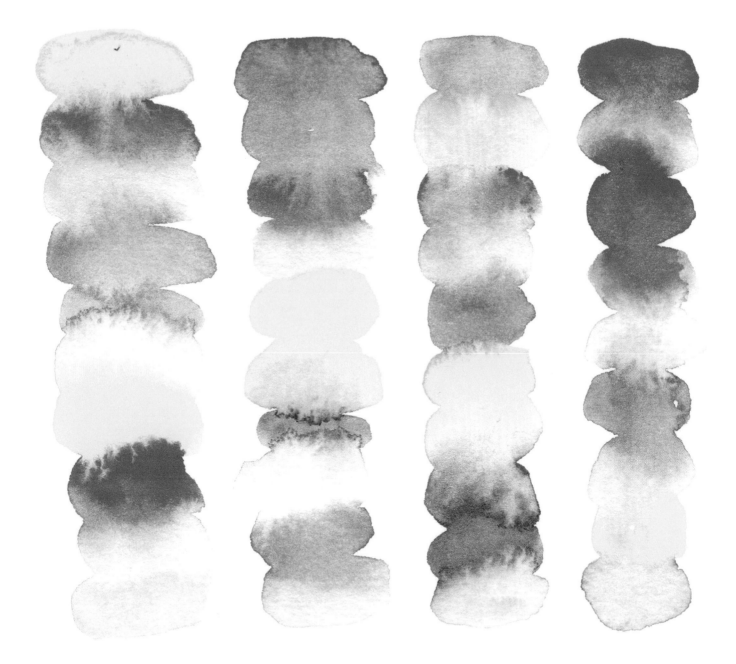

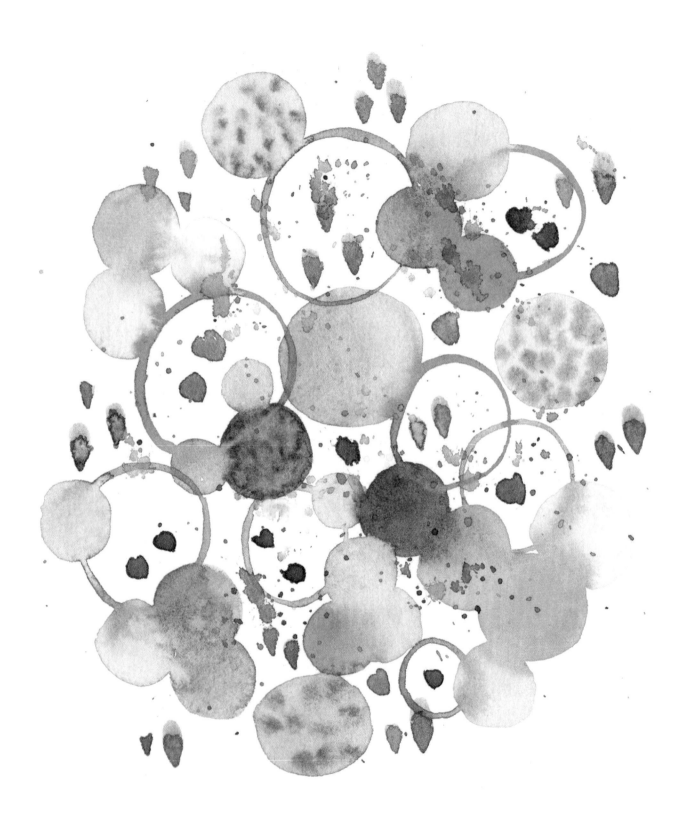

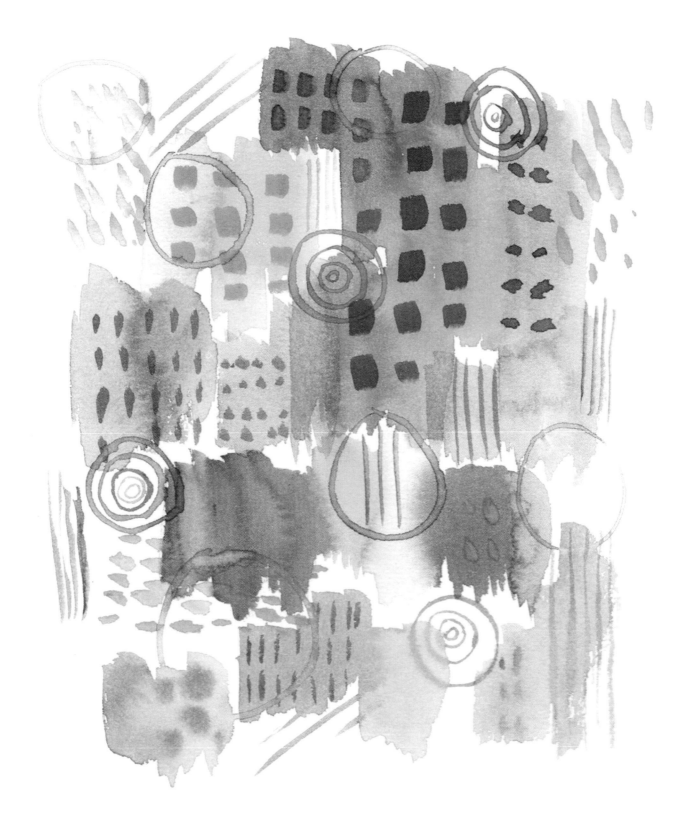

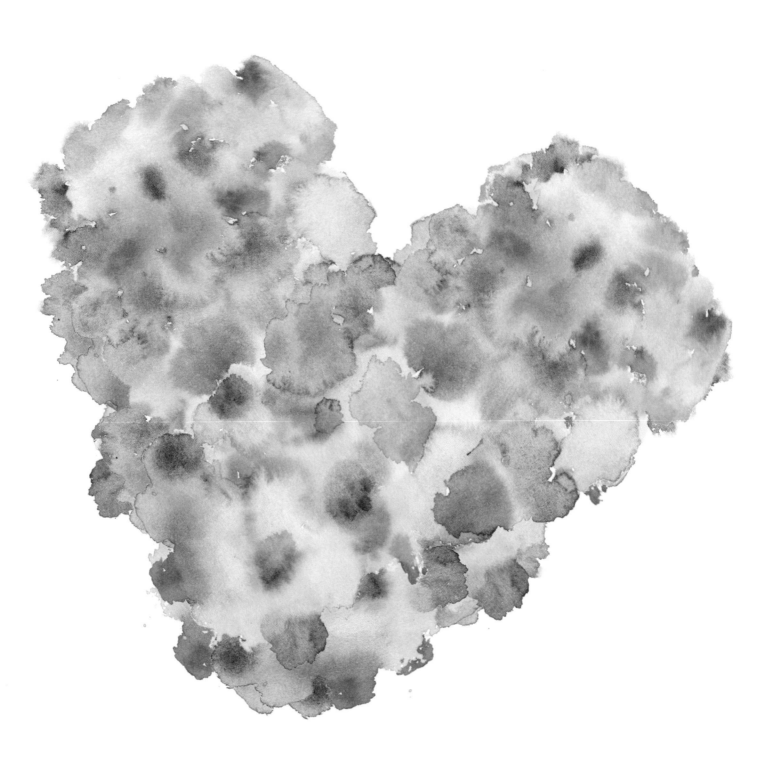

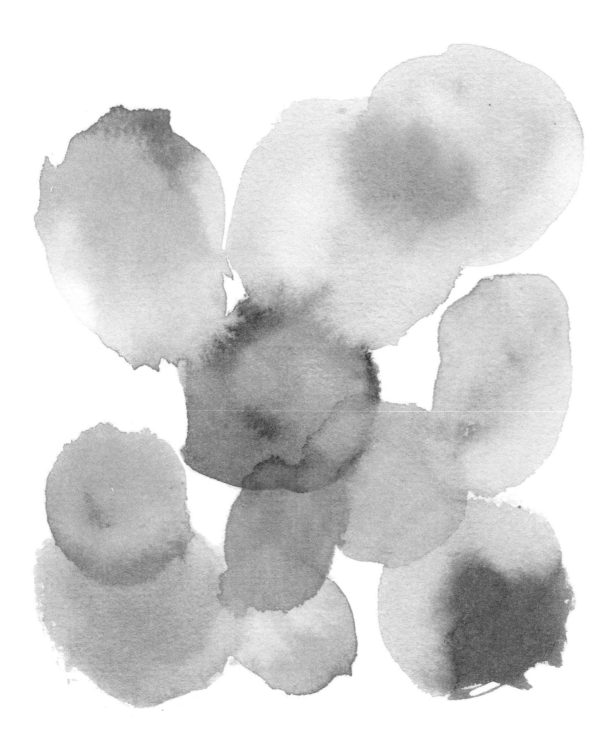

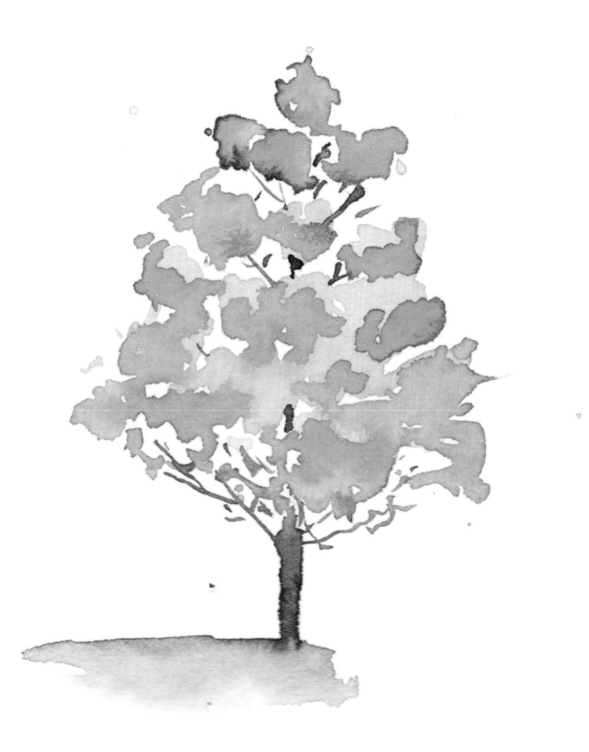

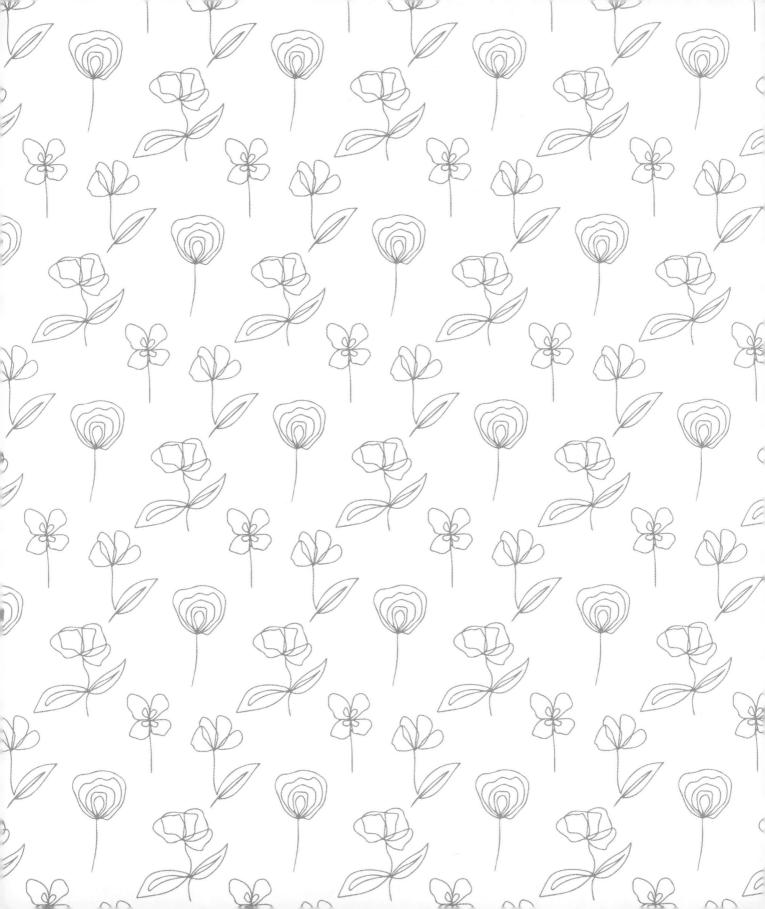

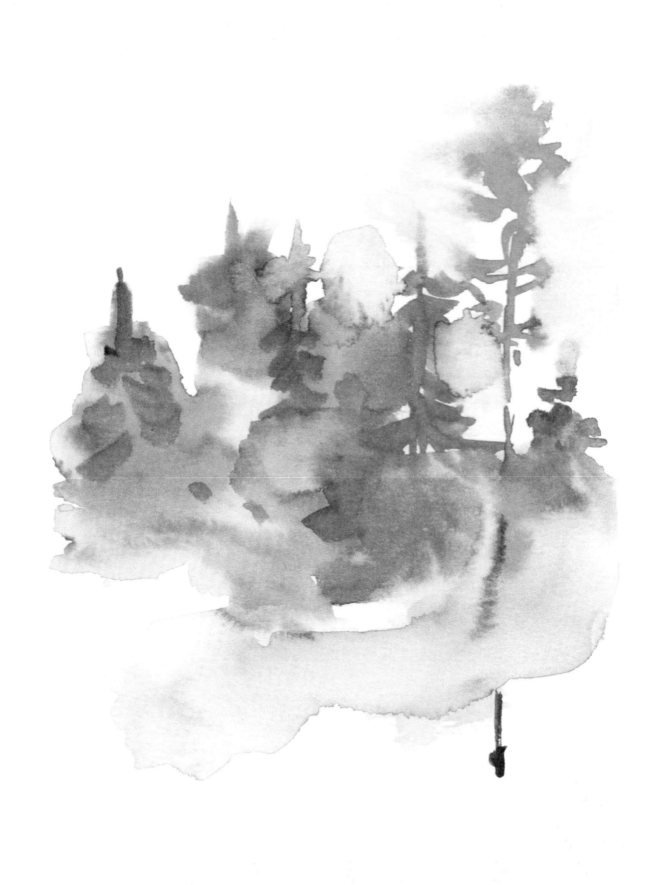

About the Artist

Hello, I'm Heinke, aka Silberstolz. I'm a one-line artist, an illustrator, and a university lecturer. Besides watercolor painting, meditative drawing using a single line has become my obsession. I love to be creative with other people and I also teach workshops. I encourage drawing and painting without judgment, and I like to focus on relaxation and attentiveness in my workshops.

My motto is live creatively! On my social media channels, listed below, you will find lots of inspiration and little videos that you can participate in and exchange with others.

Instagram @silberstolz
YouTube @silberstolz